What You See

Presented By Creative Aces

Table of Contents:

On May 6th 2015, the asexual community had their first Ace Day. It had one goal, to give the community a day where awareness was good, but pride was better. It was a celebration of being yourself. With one rule, there are no pride restrictions. To those who planned the event this meant "may the ace" was for anyone and everyone who identified as asexual. The day was filled with selfies, pride, stories, awareness, and a lot of art. Those pieces served as the first for this collection.

"You cannot be what you cannot see."

I've always loved this quote by Marian Wright Edelman, and I know it has changed the way I work as an activist. But, it is flawed. Since for many asexuals we *are* before we ever saw ourselves. This quote directly inspired the title of the project. The goal of *What You See* was to be a collection where aces could show you something. Sometimes that meant self-portraits, sometimes it meant drawing our favorite characters, other times designing adorable pride carrying mascots. Whatever piece you look at within this collection it was brought to you by and for members of the community.

Cover Artist: Ashleigh Fortier
Pikkulapsi.tumblr.com
Instagram.com/pikkulapsi

Ashleigh Fortier 2015

Intro and design: Tiffany Rose
Follow @FromPawnToQueen and ArtOverChaos.tumblr.com

No Pride Restrictions

May 8th - #AceDay

People

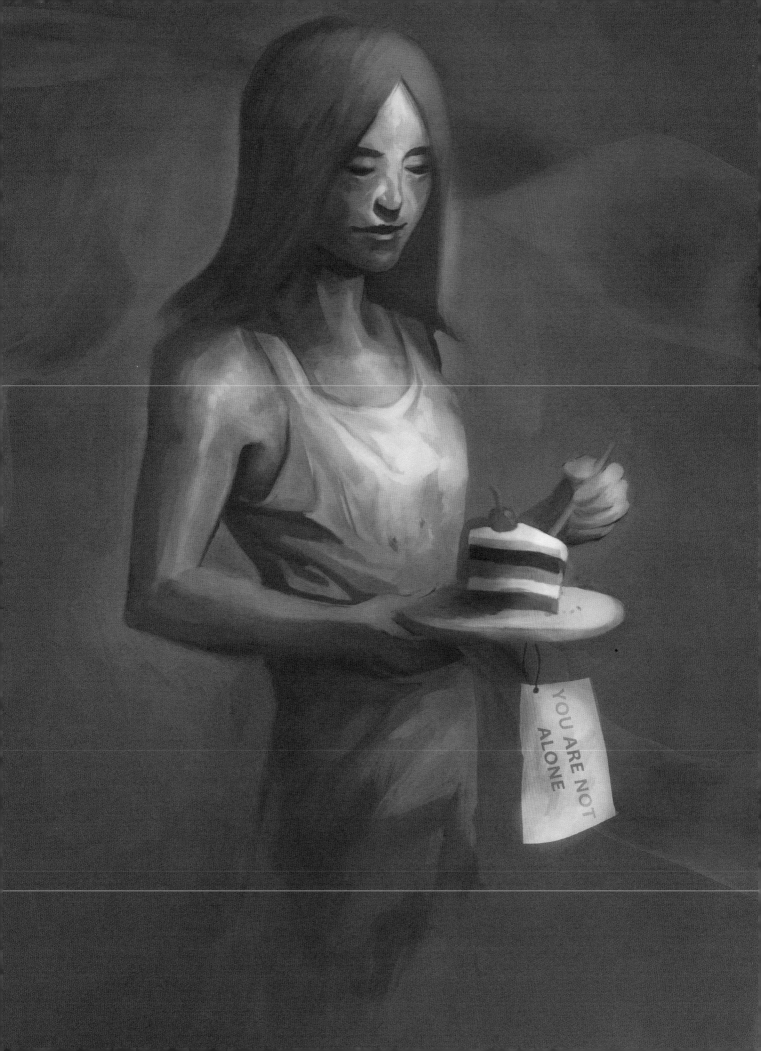

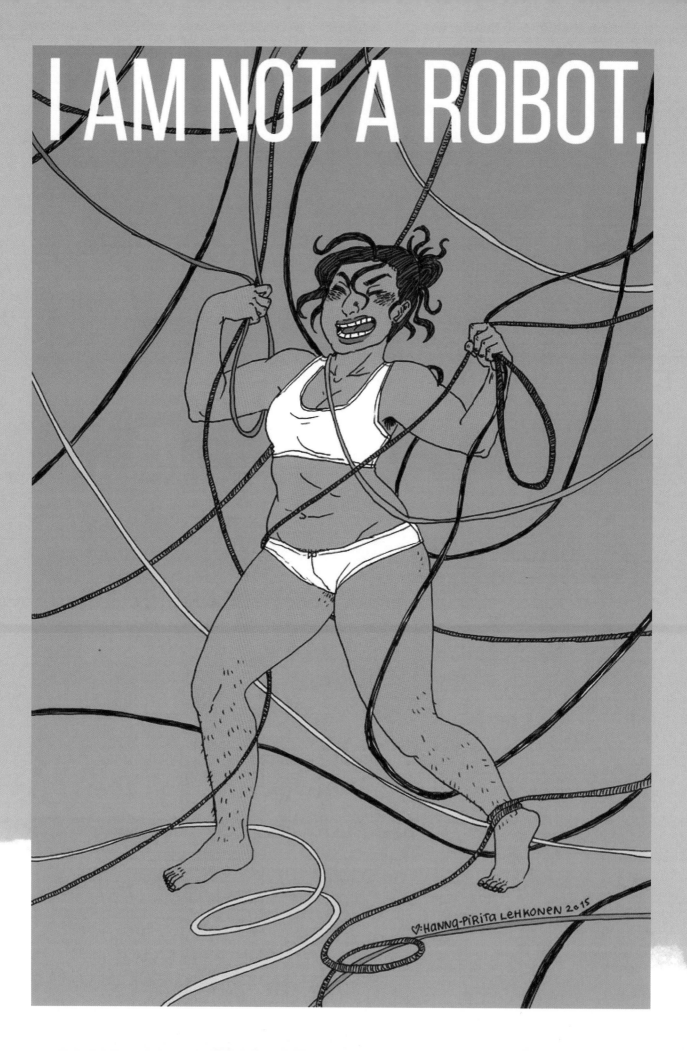

HOW TO (A)CE AN (A)ROMANTIC CANDLELIGHT DINNER?

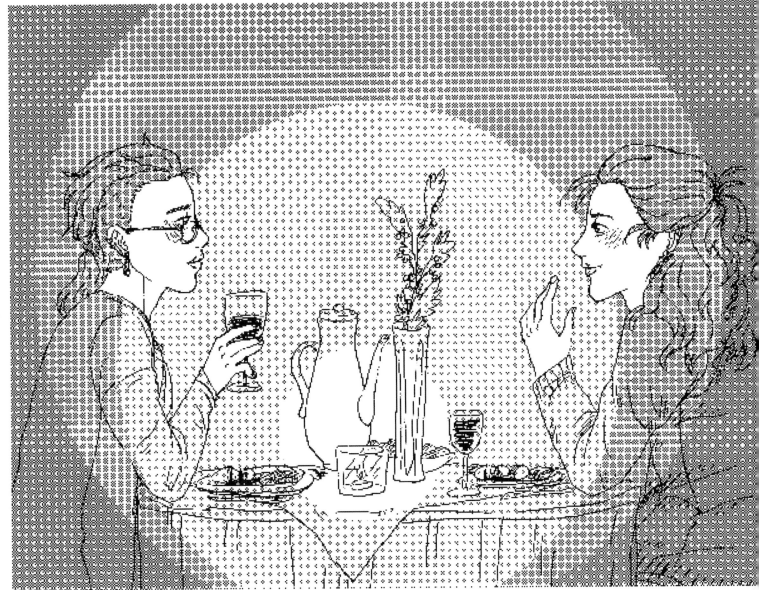

♡·HANNA·PIRITA LEHKONEN 2015

Hanna-Pirita Lehkonen

Artist Comment: I am asexual, but that doesn't mean I am a robot with no emotions and no friends. I am an extrovert and I love people and I am tired of being seen as a person without feelings. Even asexual and aromantic people can enjoy things others see as romantic. Eating a fancy dinner with a person you care for doesn't have to be sexual and romantic.
Follow @hannapirita and bestofhannapirita.tumblr.com

Ekkoberry
Artist Comment: A lighthearted piece that
reflects the asexual community's love of cake!
Follow @ekkoberry and ekkoberry.deviantart.com

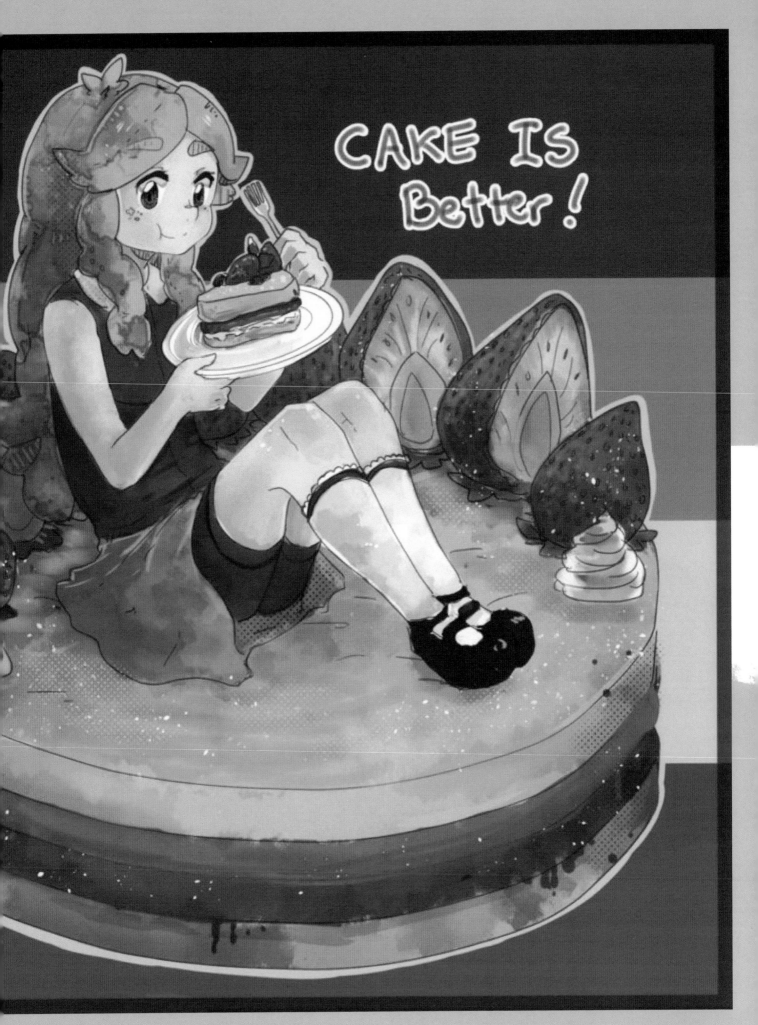

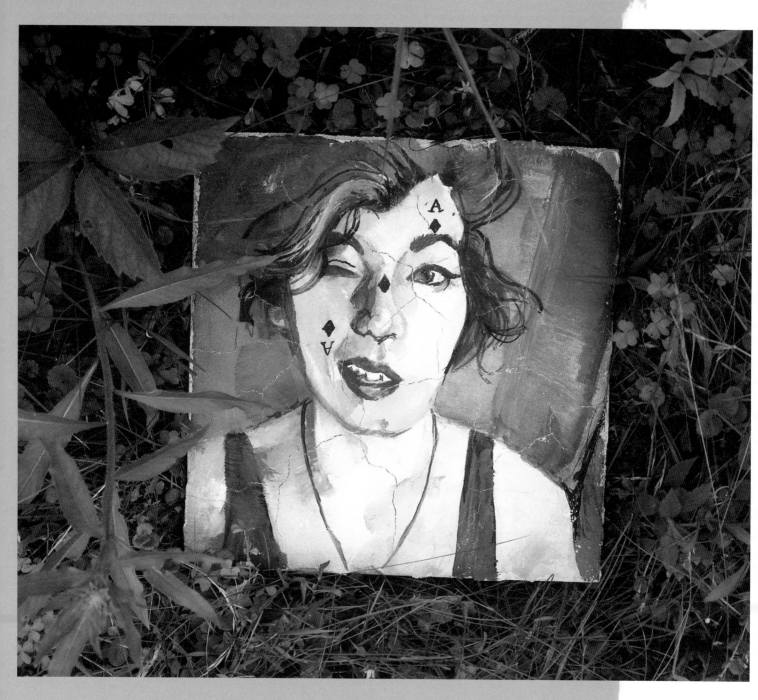

Kirby Burt

Artist Comment: My first fresco! This self-portrait of me showing off my demisexuality is now as permanent as the walls of Pompeii, or the Sistine Chapel ceiling.

Follow at kirbyburt.tumblr.com and facebook.com/pages/Kirby-Burt/796722343774255

Lexes S. Reiss Musial
Artist Comment: I'm honored to be included in
this book with many other amazing ace spectrum
artists. Despite what others may say, stay proud
and stay fabul-ace!

Follow at @contrabasselex and
contrabasse.tumblr.com/tagged/lexxy's-art

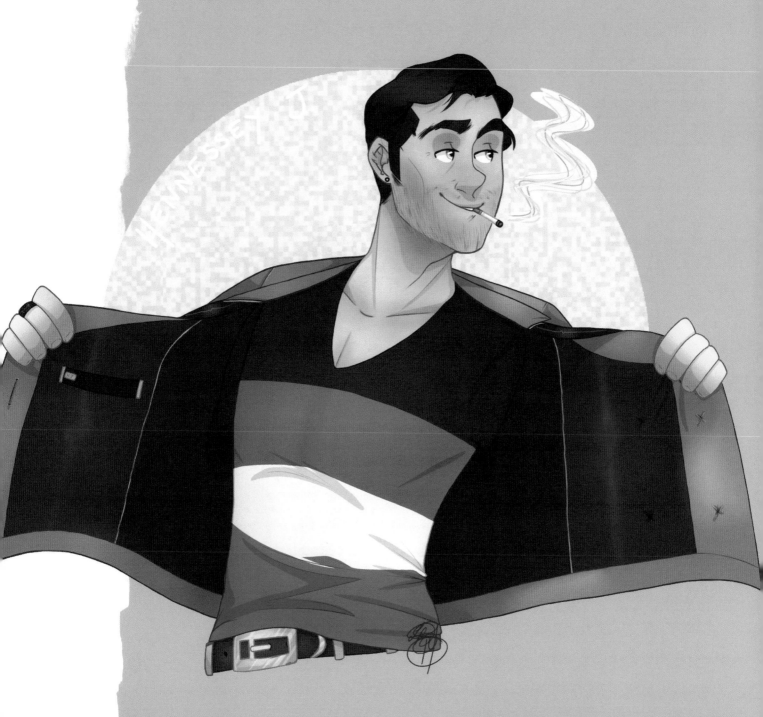

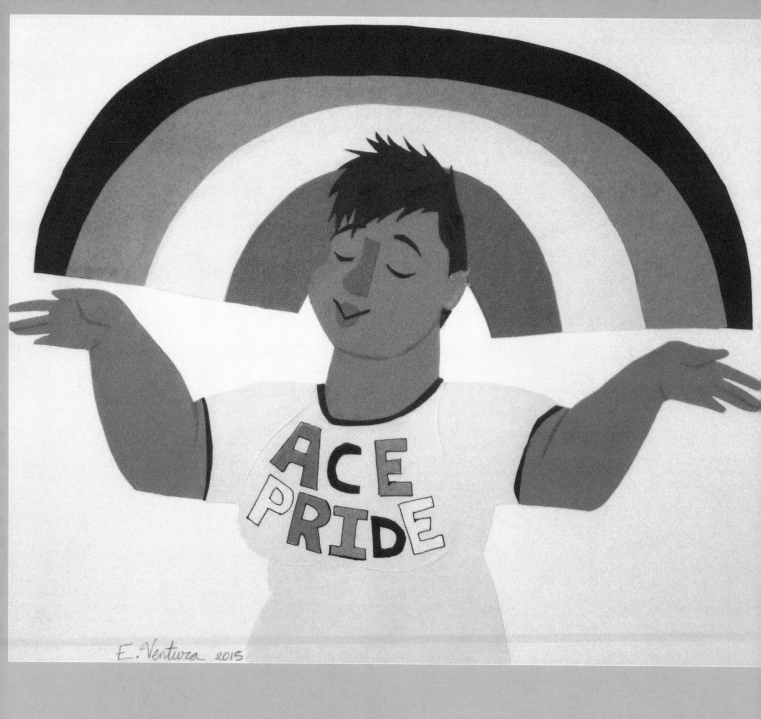

Estefania Ventura
Follow on instagram at eventur1
or contact at eventur1@outlook.com

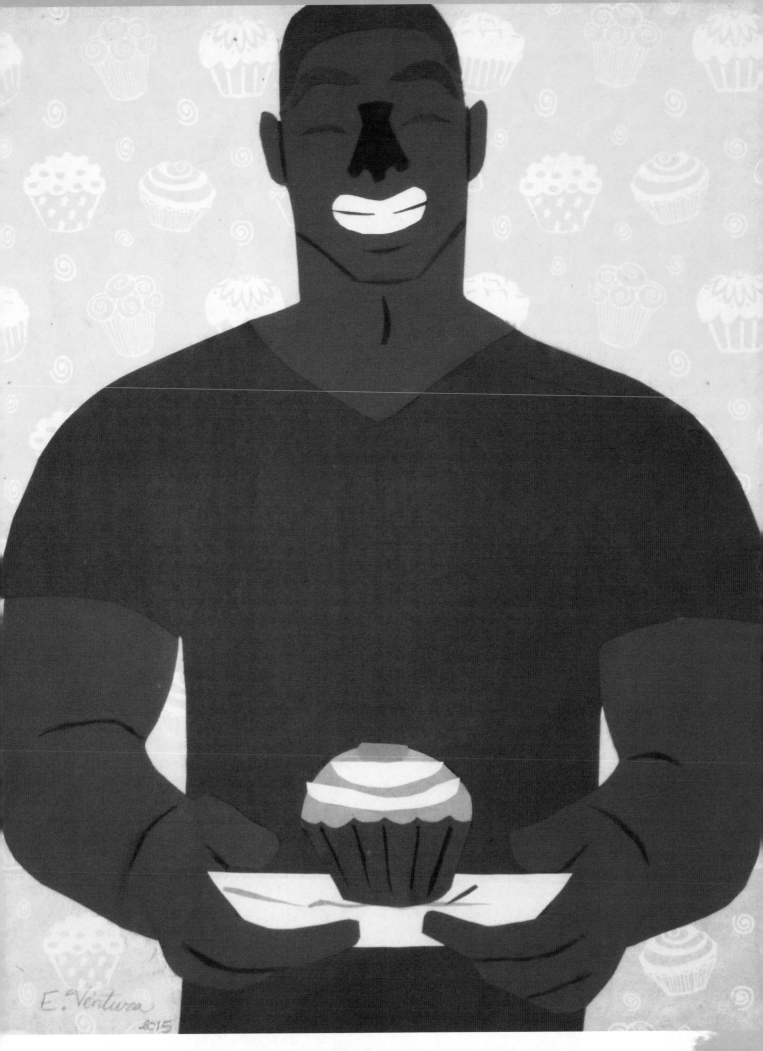

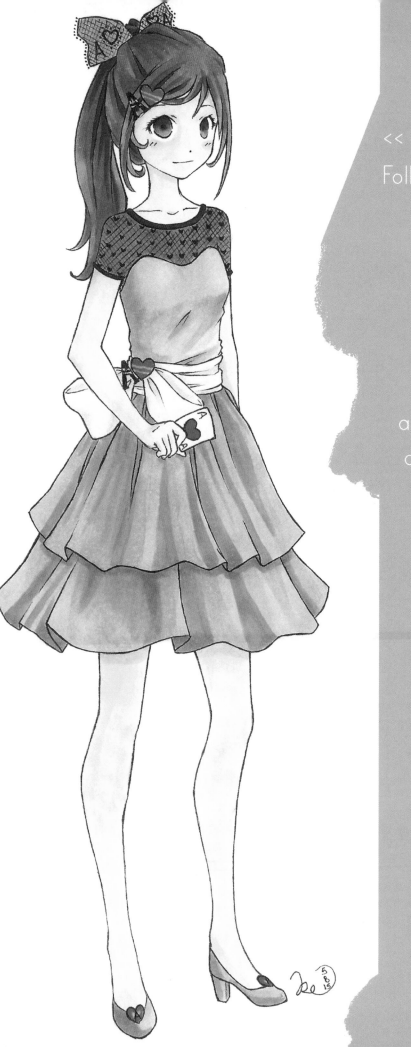

<< Artist on left: Tovato
Follow at tovato.tumblr.com

>> Artist on right: Laya Rose
Follow @layahimalaya
and layaart.tumblr.com

Artist Comment: Niavin, the
aromantic asexual protagonist
of Sinners by Eka Waterfield.

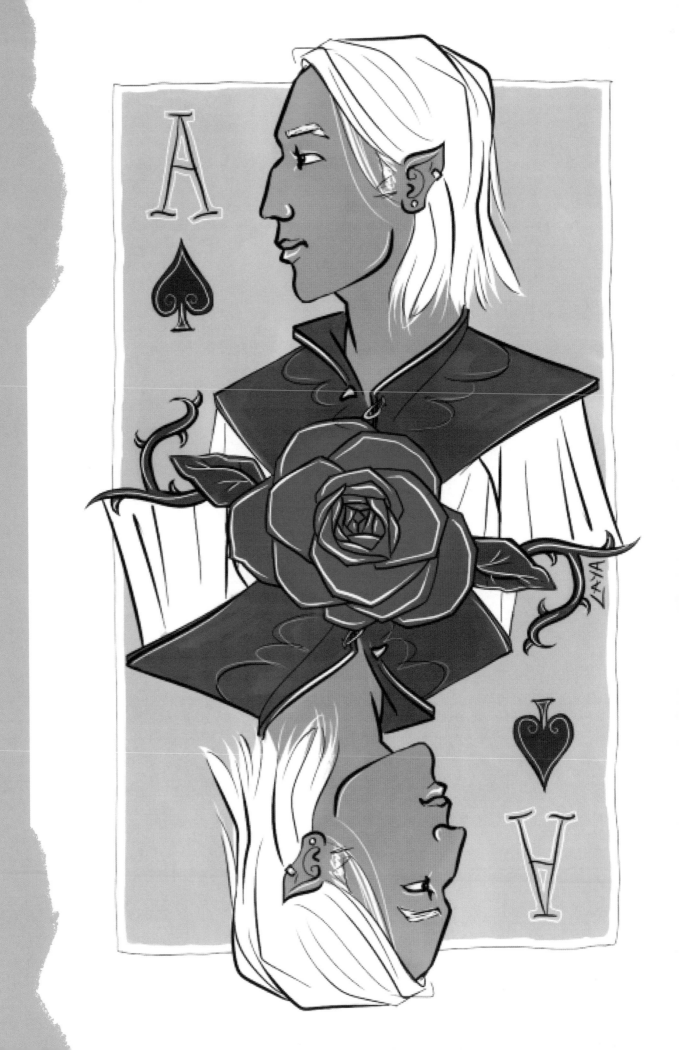

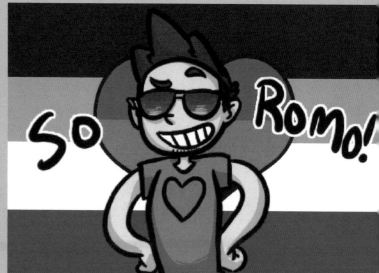

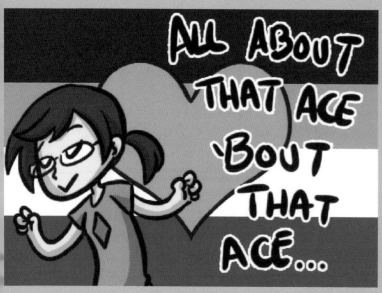

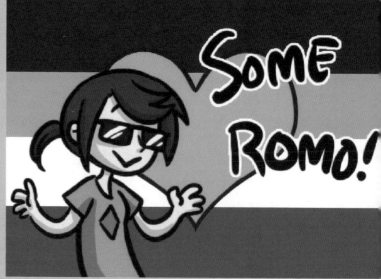

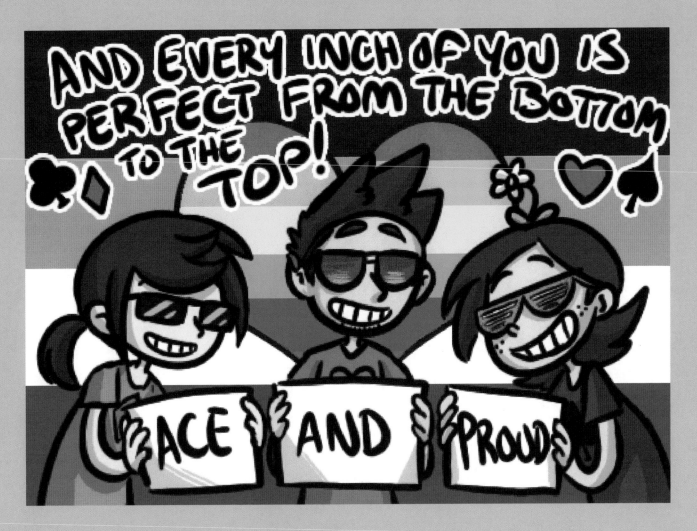

Pettyartist
Follow @pettyartist and pettyartist.tumblr.com

Artist Comment:
This is a message to all spectrums of ace people out there!
- from the Ace Trainers (Me, @kyleenim and @Gatrdile!)

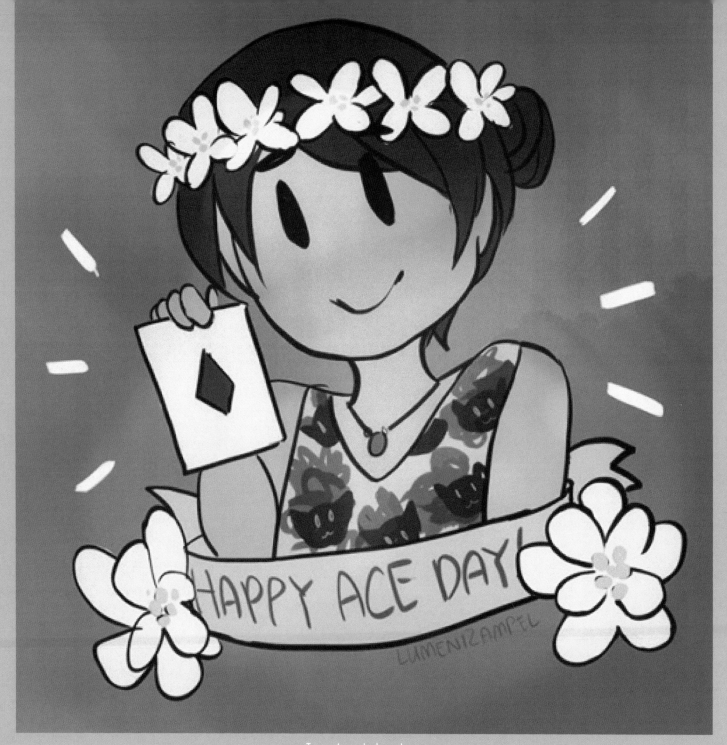

Isabel Lalic
Follow @loewen_grube and izampelart.tumblr.com

Artist Comment: I've found myself as demisexual only a few months back, but only now have I decided to celebrate it as part of my identity. Being in a somehow traditional family and culture, it's a rebellion, but I'm glad I'm myself, and I'll celebrate it everyday... but for now, I'll start with a doodle. =)

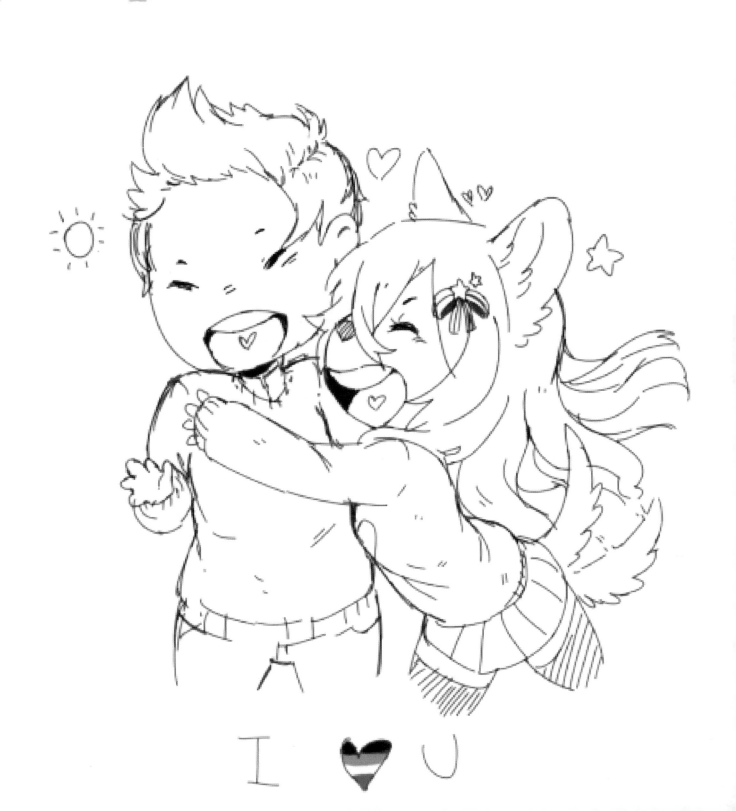

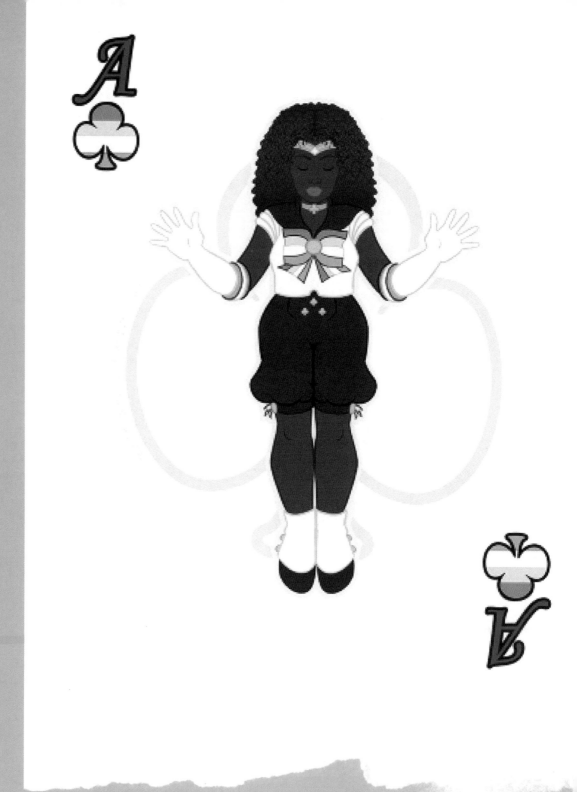

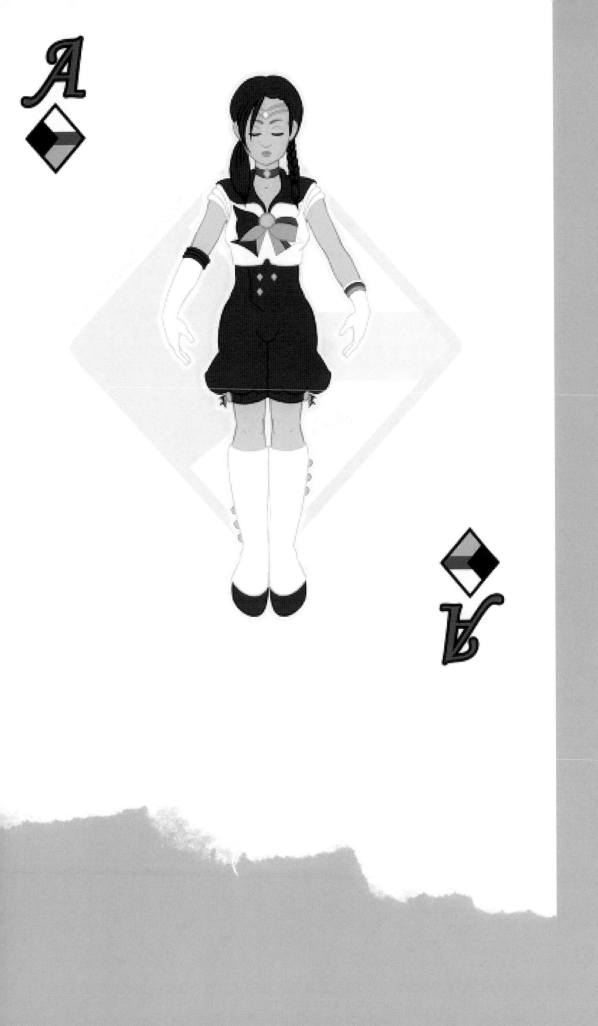

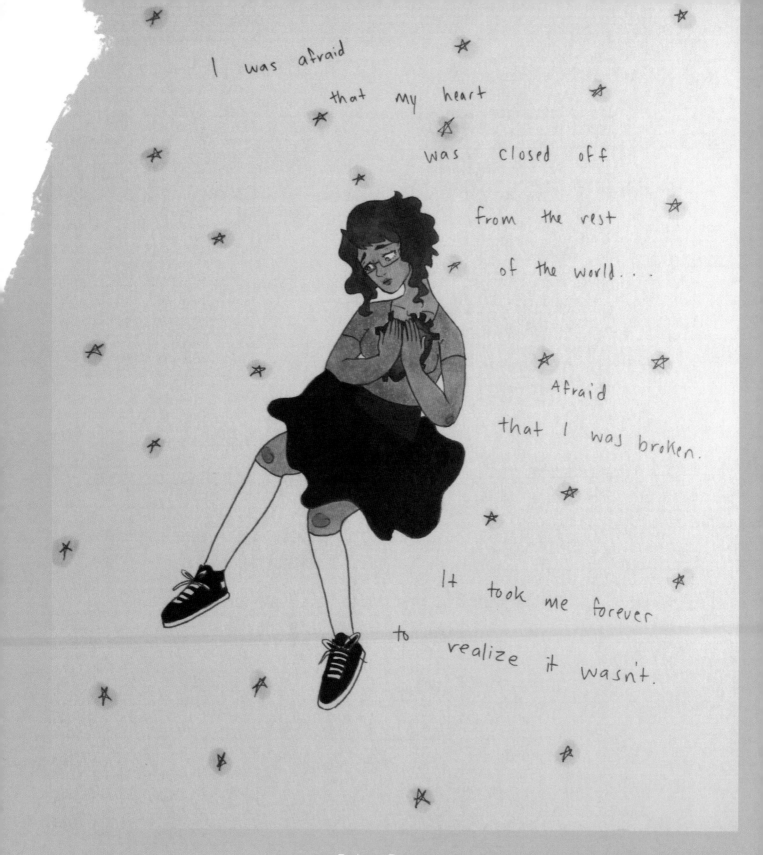

I was afraid
that my heart
was closed off
from the rest
of the world...

Afraid
that I was broken.

It took me forever
to realize it wasn't.

Julia Pereira
Follow at julia-pereira.format.com and insertfeminism.tumblr.com
Artist Comment: I'm still figuring myself out but I know one thing
for sure: I'm not alone.

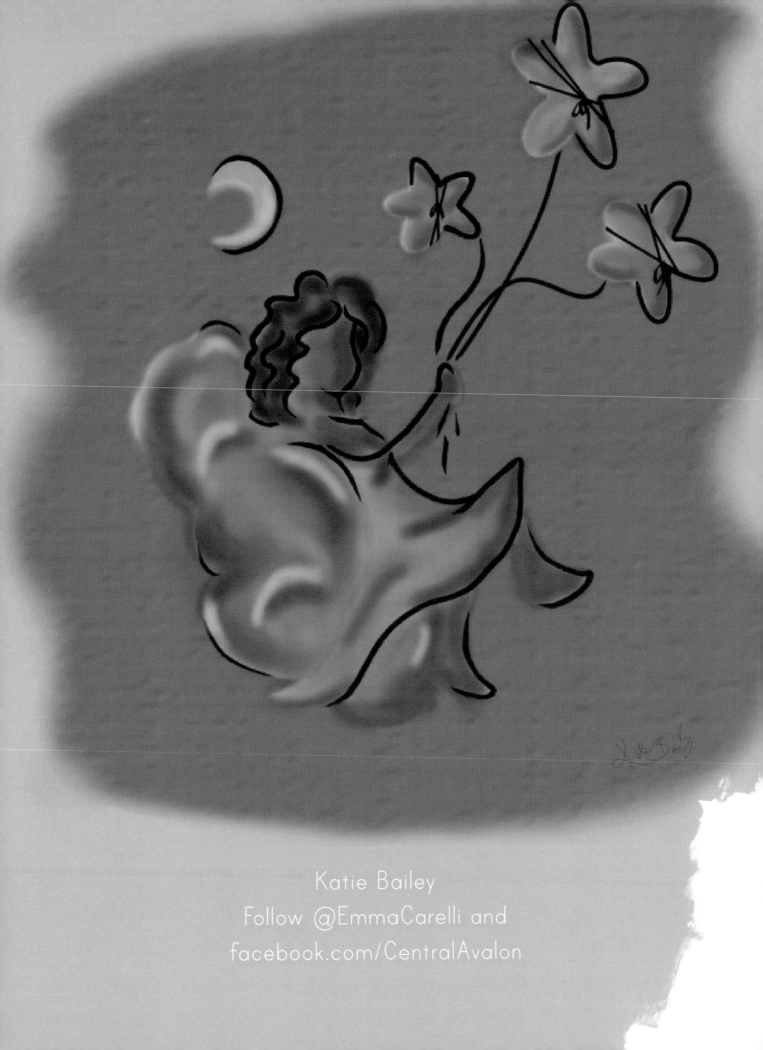

Katie Bailey
Follow @EmmaCarelli and
facebook.com/CentralAvalon

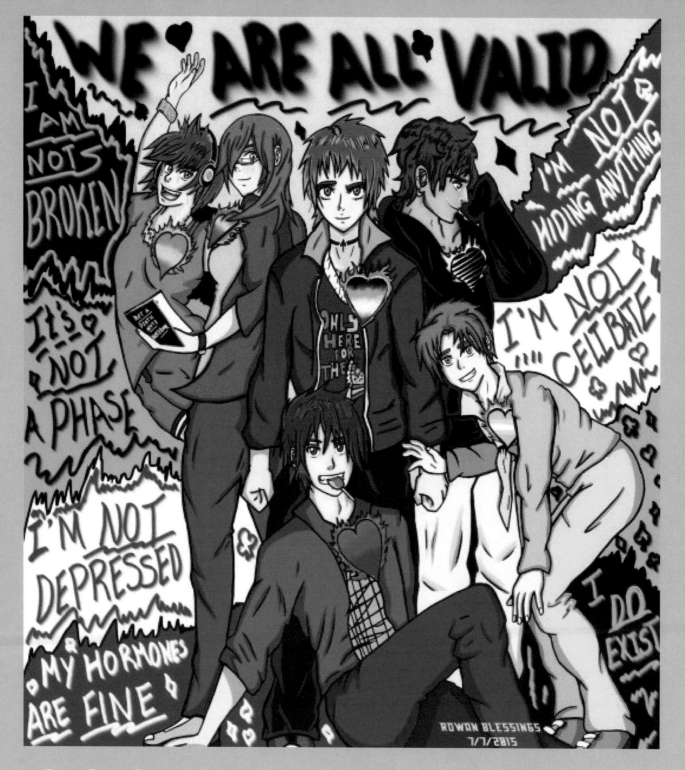

This piece can be seen as all/most the sexual orientations together or they can be seen as Asexuals of the Asexual spectrum it's up to you. Heck! It is whatever you want it to be but one thing I want to make very clear is ... People can be mean and no matter what the negative things they may tell you just throw it behind you or in one ear out the other.

Cyan Grey

Follow at cyangrey.tumblr.com and rosethorn-chi.deviantart.com

Artist Comment: This is amazing! I love being able to represent my community.

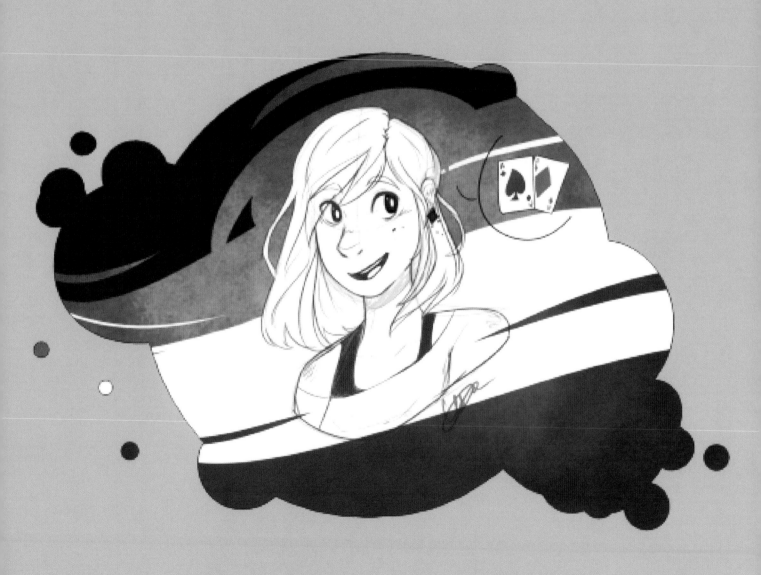

Pride

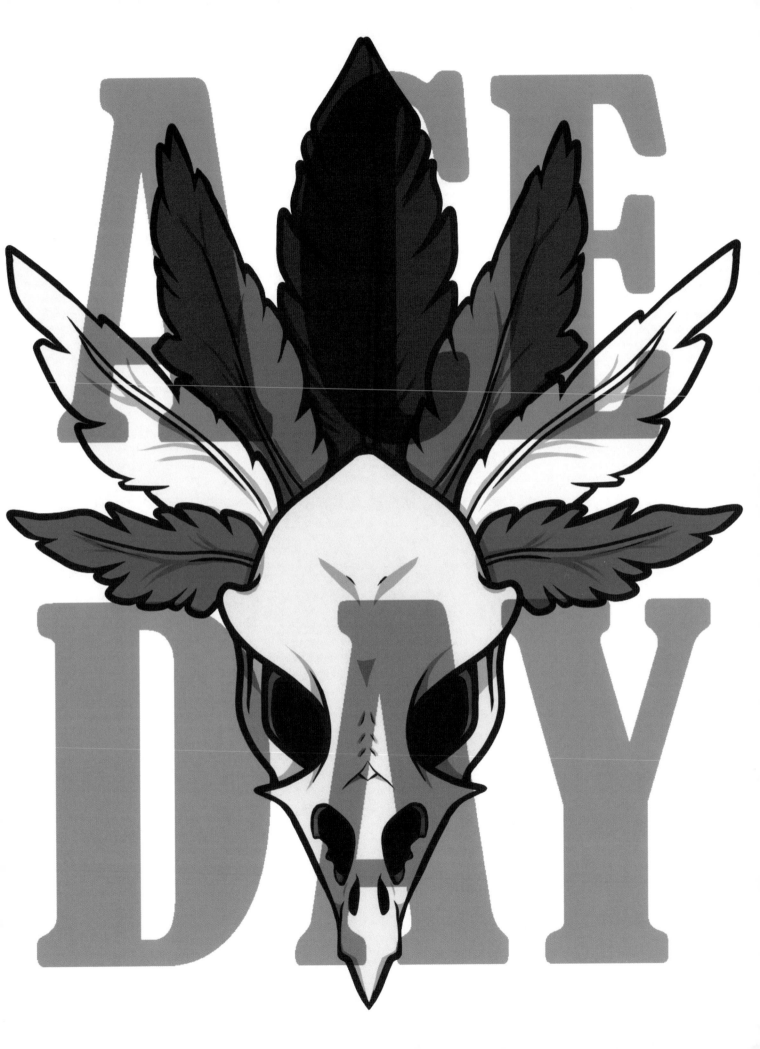

Sheryn Karr
Follow at princessloki.weebly.com
and nervousbeetle.deviantart.com

Artist Comment: I decided to turn a class assignment into
something that represents myself and the ace community.

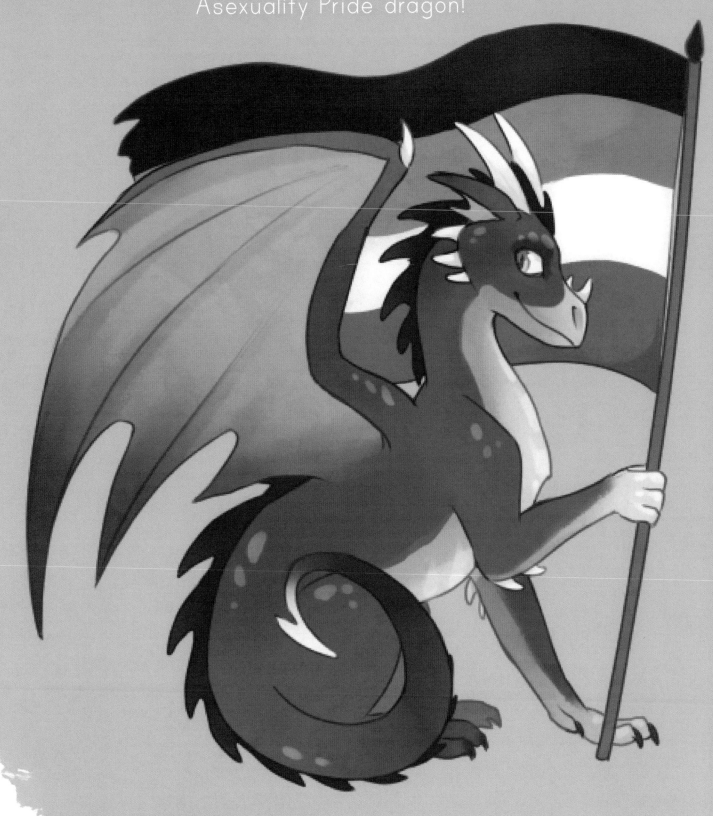

A

I am Asexual! I dont feel sexual attraction. That's a little uncomon—I am 1 in 100. (how neato is that??) And that is perfectly natural. I am totes normal, yo. And I'm HAPPY!! It's not a phase. My current feelings are more real than anything the future holds. My orientation is real and valid. No one gets to label me but ME! I am HELLA PUMPED that there's a WORD for how I feel! makes SO the world MUCH more sense now! (like, holy shit) Date of Self Discovery: Jan. 25 2015 There is a place for me in the LGBTQIA+ community! (I love you cutie pies♥) I am not broken. I am not missing out on anything. I am enough! The only "fuck" used in conjunction with my person should be proceeded by "cute as". I am lovely and delightful and rad and perfect JUST the way I am. I didn't choose to be Ace. But I wouldn't choose to be any other way than the way I am. I am the only me. I am the best me! I love who I am!! #AceCardDay

A

Rebecca Cook

Reads: I am Asexual! I don't feel sexual attraction. That's a little uncommon—I am 1 in 100 (how neato is that??) And that is perfectly natural. I am totes normal, yo. And I'm HAPPY!! It's not a phase. My current feelings are more real than anything the future holds. My orientation is real and valid. No one gets to label me but ME! I am HELLA PUMPED that there's a WORD for how I feel! The world makes SO MUCH more sense now! (like, holy shit) Date of Self Discovery: Jan. 25, 2015. There is a place for me in the LGBTQIA+ community! (I love you cutie pies <3) I am not broken. I am not missing out on anything. I am enough! The only 'fuck' used in conjunction with my person should be proceeded by 'cute as'. I am lovely and delightful and rad and perfect JUST the way I am! I didn't choose to be Ace. But I wouldn't choose to be any other way than the way I am! I am the only me. I am the best me! I love who I am!! #AceCardDay

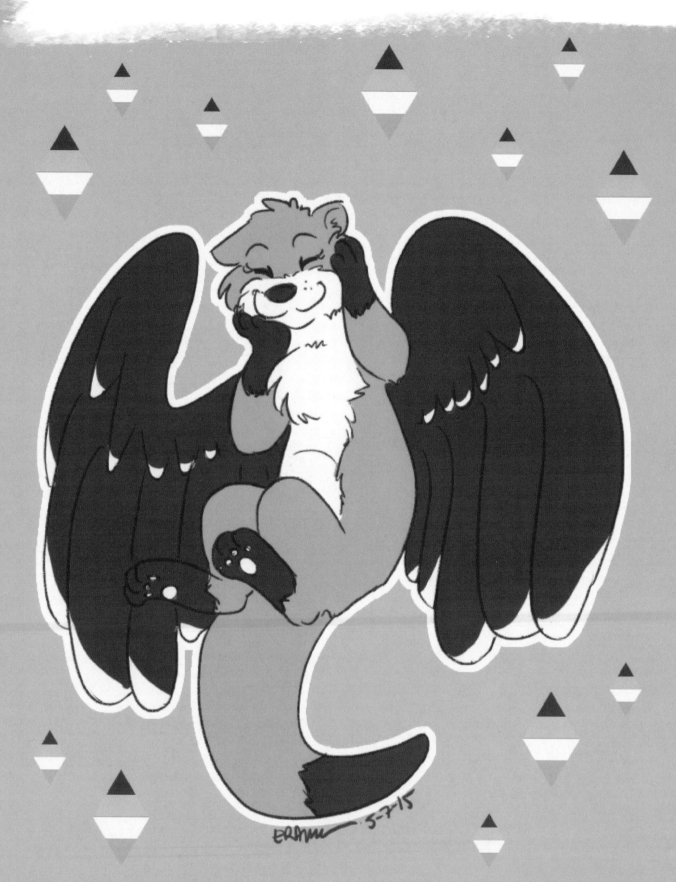

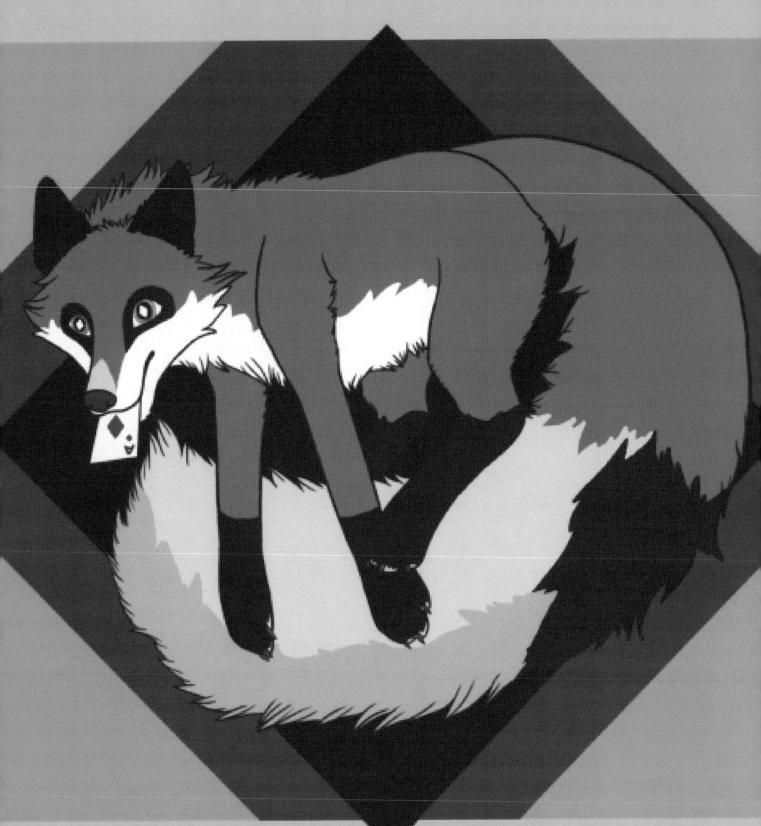

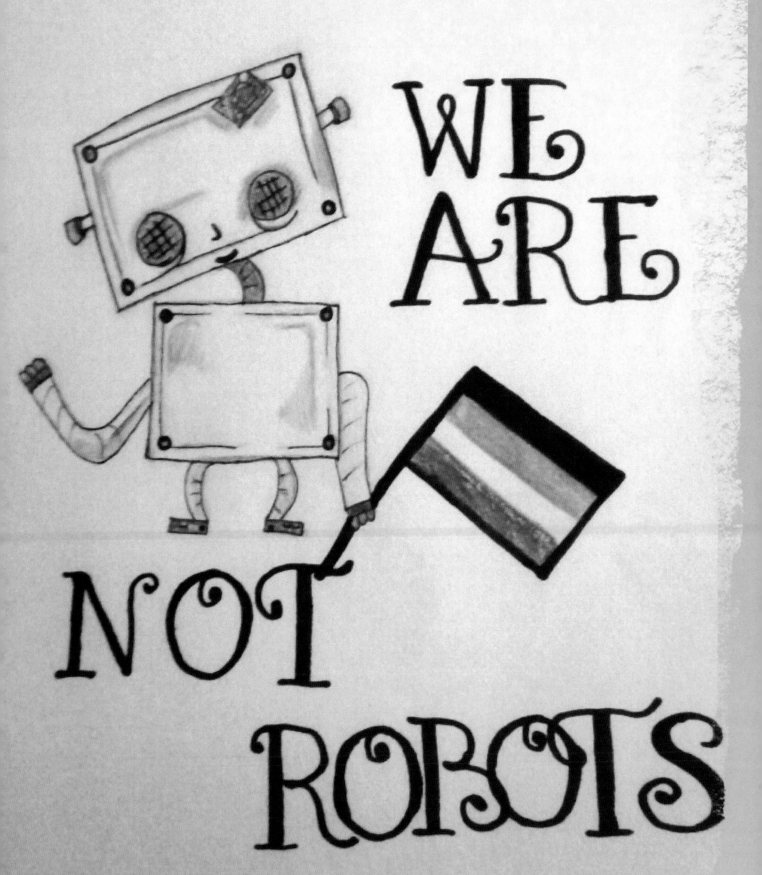

<< Artist on left: Jace Isaak
inferno-rose.tumblr.com

A Note From Fuck Yeah Asexual:
After seeing this collection I hope you are reaffirmed of a few things. You are not alone. You are a part of a vibrant community that not only works for bigger awareness of all aces, but one that is full of pride. Not only in oneself, but each other. It has been my personal pleasure to talk with the artists in this collection. Some of which are fiercely protective, while other have quiet voices that are just as noble. Asexuality is not a blank canvas for others to paint. It is our own picture, and I hope you paint yours with everything your heart wants.
| Follow @FYeahAsexual or fuckyeahasexual.tumblr.com

A Note From The Asexuality Blog: This collection is the culmination of everything good with the first observance of Ace Day. All I ever wanted to do with Ace Day was bring the community together and exhibit who we all are as people despite the misconceptions we face for our orientations. This book is proof that despite the event's initial issues, the community was able to come together and create beauty and a sense of unity. Every time I look through the pieces submitted for this, I'm reminded of just how wonderful the ace community is and how proud I am to be a part of it.

My biggest activism dream has always been to, in some way, contribute and promote the sense of an ace culture, and this collection is helping that dream to come true. Art is emotion and passion, and this helps to provide evidence that we, as aces, are not robotic or childish. We are people with purpose, innovation, and inspiration and we're immensely proud of our ace identities. | Follow @AsexualityBlog and theasexualityblog.tumblr.com

| Learn More: creative-aces.tumblr.com | theasexualityblog.com

What You See

First Edition: Fall 2015

Made in the USA
Lexington, KY
20 October 2015